Nick

Clever Stuff

you can do with your

Apple Gadgets

covers OS X Mountain Lion and iOS6

In easy steps is an imprint of In Easy Steps Limited
4 Chapel Court · 42 Holly Walk · Leamington Spa
Warwickshire · United Kingdom · CV32 4YS
www.ineasysteps.com

Notice of Liability
Every effort has been made to ensure that this book contains accurate and current information. However, In Easy Steps Limited and the author shall not be liable for any loss or damage suffered by readers as a result of any information contained herein. All prices stated in the book are correct at the time of printing.

Trademarks
All trademarks are acknowledged as belonging to their respective companies.

In Easy Steps Limited supports The Forest Stewardship Council (FSC), the leading international forest certification organisation. All our titles that are printed on Greenpeace approved FSC certified paper carry the FSC logo.

MIX
Paper from
responsible sources
FSC® C020837

Printed and bound in the United Kingdom
ISBN 978-1-84078-566-1

Contents

1 Linking it all up

The concept of a time when all computers and mobile gadgets were fully joined up and integrated was once the holy grail of the digital world. But this is now very much a reality and Apple is leading the way. Mac computers, iPhones, iPads and even iPods can now share files, notifications, updates, photos and much more, effortlessly. This chapter shows how this all works and how you can connect all of your Apple gadgets together.

How it all works

When computing gadgets are linked together and working well (as Apple ones invariably do) it can seem like an effortless exercise. However, there is a lot of technology involved to make this happen:

- **The hardware.** This is the computers, mobile gadgets and smartphones. In terms of Apple this includes the iMac, Mac Mini and Mac Pro desktop computers, the MacBook laptops, the iPad, the iPod Touch and the iPhone. They can all be used on their own but they can also all be linked up

- **The software.** This is the apps (applications) that are used on the computers and mobile gadgets. In terms of integration, the important ones are those that can communicate with the same apps on other gadgets. For Apple these include Notes, Reminders, Contacts, Calendar, iTunes, FaceTime, Messages, Safari and Mail

- **The operating systems.** This is the software that runs the computers and mobile gadgets. On Mac desktops and laptops this is known as OS X Mountain Lion; on the mobile gadgets it is iOS 6. Although they are not exactly the same they are both designed so that they can work seamlessly with each other

- **iCloud.** This is the digital glue that holds together the gadgets, operating systems and apps so that everything can talk to each other. Without iCloud there would just be a collection of stylish gadgets that do a lot of clever things individually

Don't forget

Of course, all Apple gadgets work extremely well on their own and most of the items in this book can be used in isolation.

Showing your ID

In addition to the items on the previous page, another essential in terms of using Apple gadgets is an Apple ID. This is a free, online identifier that is used to access a variety of apps and services:

- Connecting to iCloud

- Downloading apps from the App Store

- Buying music from iTunes

- Communicating with FaceTime and Messages

- Playing games in the Game Center

To set up an Apple ID you require an active email address and you have to select a password when you register. You can set up an Apple ID when you first start using your Apple computer or mobile gadget (there is a step in the setup process that asks if you want to create an Apple ID) or you will be prompted to create an Apple ID when you try and use one of the services that requires one.

You can also create an Apple ID on the Apple website at appleid.apple.com

1 Click on the **Create an Apple ID** button `Create an Apple ID`

2 Complete the required fields on the form to create your Apple ID (you will be sent an email to the address that you have provided and this is used as authorization before your Apple ID can be created)

Create an Apple ID.

Choose an Apple ID and password.
Enter your primary email address as your Apple ID. This will be used as the contact email address for your account. Please note that this email address must be verified before you can use certain Apple services.

Apple ID	@mac.com
Password	••••••
Confirm Password	••••••

Create a security question.
Select a security question or create one of your own. This question will help us verify your identity should you forget your password.

Purchasing with your ID

Once you have obtained an Apple ID you are fully equipped to use the services to which it provides access. In most cases, such as FaceTime and Game Center, it is simply a case of signing-in with your ID. However, if you want to buy anything, such as apps from the App Store, or music from the iTunes Store you will need to enter your ID before you complete your purchase.

1 Once you have located the item you want to buy you will be prompted to enter your ID (you can also create one at this stage)

2 If you want to buy something using another app, you will have to enter your ID again

3 For some services there is a confirmation window. Click on the **Buy** button if you want to continue with your purchase

Don't forget

If you want to buy items with your Apple ID you will also have to provide credit or debit card details. These will be used whenever you make a purchase from an Apple service.

Get your head in the iCloud

Armed with an Apple ID you can then setup iCloud:

1 For Mac computers running Mountain Lion (or its predecessor, Lion) access the **System Preferences**; for an iOS 6 gadget access the **Settings** app. Both are accessed with this button

2 For both, access the **iCloud** option and enter your Apple ID to register for iCloud

3 For iOS gadgets, swipe the buttons to **On** to include them in iCloud

4 For OS X computers check on the boxes to include them in iCloud

Sharing with iCloud

One of the many, great things about iCloud is that once it has been set up you can largely forget about it and let it do its stuff in the background. When an iCloud item has been created it will be pushed to all of your other iCloud-enabled gadgets automatically. For instance:

1 Create a note on a MacBook using OS X Mountain Lion

2 It appears on any mobile gadgets using iOS 6 (make sure that the note is created within the iCloud account in the **Notes** app)

3 Take a photo with an iOS 6 gadget

4 It is available via iPhoto on a Mac computer with Mountain Lion

Know your OS's

It is always useful to know which version of the operating system is installed on your computer or mobile gadget and to see if there are any updates available. To do this for OS X Mountain Lion:

1 Click on the Apple icon and click on the **About This Mac** link

2 The version of OS X is displayed

3 Click on the **Software Update** button to see if there are any available updates

To check the iOS version for an iPad, iPhone or iPod Touch:

1 Access the **General** section in the **Settings** app

2 Tap on the **Software Update** link

3 Details of the iOS are displayed. If there is an update available tap on the **Install Now** button

It's not set in stone

All of the apps on Apple gadgets can be used very effectively in their default state. But if you want to customize your apps to your own specifications there are almost endless options for this:

1 For iOS 6 gadgets, tap on the **Settings** app

2 Tap on an item to view and select the available settings

3 For OS X Mountain Lion computers, click on the **System Preferences** button

4 Click on an item within the **System Preferences** to view and select the available settings

State your preference

Another source of customization is available on Apple computers with OS X Mountain Lion. Most apps have their own individual preferences that can be accessed from their menu bar. To use these:

1 Open an app, such as the Safari web browser, and click on its name on the main menu bar and click on the **Preferences** link

2 Make any selections as required

3 Use the buttons along the top of the Preferences window to view and select more options

4 Other apps, such as iPhoto, have their own range of Preferences

Don't forget

iOS apps are generally self-contained, i.e. they do not interact with other apps. This is a security feature so that any potential viruses cannot spread to other apps.

Share, share and share again

iCloud enables you to share your content between your own Apple gadgets. There is also a **Share** button that is available on both Apple computers and mobile gadgets. This can be used to share content in a variety of ways, applicable to the type of app from which they are being shared. To do this:

1 Click on the **Share** button, which is available on computers running Mountain Lion and also on iOS 6 gadgets

2 Depending on the app being used, the available options will differ

3 For an app such as iPhoto (or Photos on iOS 6 gadgets) the options include social media sites such as Facebook and Twitter, Email and Messages

4 An app such as Notes will have more limited options because of the type of content being created

2 Getting things done

Whether it is creating calendar appointments, taking notes or drafting a letter, Apple gadgets are excellent for productivity tasks. This chapter shows how to undertake some of these tasks and also share them between different gadgets.

Talk to me, Siri

Siri is the voice assistant for iOS 6 gadgets that provides answers to a variety of questions by looking at your gadget and also a selection of web services. You can ask Siri questions relating to the apps on your iOS 6 gadget and also general questions, such as weather conditions around the world, or sports results.

1 Hold down the **Home** button until the Siri window appears

2 To find something from your iOS 6 apps, ask a question such as, **Show me my reminders** (tap on the microphone icon to ask another question)

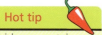

Hot tip

Siri has a certain amount of personality and it can be fun asking some more random questions such as, **What do you look like Siri?** or **How old are you Siri?**

Siri can also find information from across the Web and related web services:

1 Siri can provide sports results, for certain sports in certain countries, such as in response to the question, **How did the New England Patriots get on in their last match?**

2 Siri is also knowledgeable about a range of other subjects, such as movies that filmstars appear in and the weather around the world

3 However, even Siri's knowledge is limited and if there is a subject it does not recognize it will

own up and offer to **Search the web** instead

Take note

The Notes app can be used to jot down ideas, thoughts and reminders. It can also be set up so that notes can be shared across Apple gadgets, using iCloud.

1 Access the **Notes** app from this icon

2 Enter text for the note here

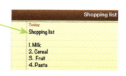

3 As each note is added it appears in the list in the left-hand panel

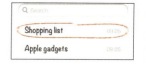

4 Tap on the **Accounts** button on an iOS 6 gadget, or select **Notes > Accounts** from a Mountain Lion computer, to select whether the notes appear in iCloud or just on your gadget

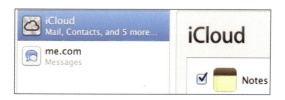

Never forget

If you are worried about forgetting anything, the Reminders app can put your mind at rest.

1 Access the **Reminders** app from this icon

2 Click or tap here to add a new reminder

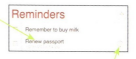

3 Click on the **i** button on a Mountain Lion computer, or tap on the reminder on an iOS 6 gadget to enter a date and time for the reminder

4 Drag the **Remind Me On a Day** button to **On**

5 Enter a date and time for the reminder and select the **Done** button

6 When the date and time arrives the reminder will appear on the screen

Entering quick events

The Calendar app can be used to enter important dates such as birthdays, anniversaries and family events. Different types of calendars can be created on Mountain Lion computers and these will then be available on iOS 6 gadgets. It is also possible to create quick entries on all gadgets:

1 Access the **Calendar** app from this icon

2 Click on this button on a Mountain Lion computer and enter the name for the event (tap and hold on an iOS 6 gadget to create a new entry)

3 Enter details for the event and click or tap on the **Done** button

Don't forget

Alerts can also be set for calendar events. This is done at the same time as entering the details in Step 3.

Calling your contacts

Video calling is a great way to keep in touch and it can be done on Apple gadgets with the FaceTime app.

1 Click or tap on this icon to access **FaceTime**

2 Select a contact from your **Contacts** list

3 Click or tap on the contact's phone number or Mac email address (they also need to have a FaceTime-enabled gadget to accept the video call)

4 Click or tap on the **Accept** button to accept an incoming FaceTime call

5 On an iOS 6 gadget, FaceTime calls can be made from the **Contacts** app. Open it and select a contact

6 Tap on the **FaceTime** button and select a phone number or email address to use for the call

Viewing notifications

The Notifications feature is available across all Apple gadgets, with either Mountain Lion or iOS 6. This can be set up so a range of items is displayed in the Notification Center: This includes:

- Emails

- Reminders

- Calendar events

- Tweets from Twitter

- Facebook updates

- Software updates

- FaceTime and Messages alerts

To set up Notifications:

1 Within **System Preferences** on a Mountain Lion computer, or the **Settings** app on an iOS 6 gadget, select the **Notifications** button

2 Select the items that you want to appear in the Notification Center. For iOS 6 apps, tap on the app and slide this button to **On**

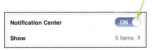

3 For Mountain Lion apps, select an app and check off the **Show in Notification Center** box to remove it from the Notification Center

4 Select an option for how the alert appears. The **Banners** style appears briefly and then disappears. The **Alerts** style stays on screen until it is dismissed

Viewing Notifications

Once Notifications have been set up, they appear on screen according to the selection in Step 4 above. All Notifications can also be viewed in the Notification Center. To do this:

1 On iOS 6 gadgets, drag down from the top, middle, of the screen

2 On Mountain Lion computers, click on the top right-hand corner (or drag left with two fingers from the right side of a trackpad or Magic Trackpad)

Do Not Disturb

Although Notifications can be set so that you never miss a new message, or alert, there may be times when you do not want to receive any calls or audio alerts on your iOS 6 gadgets. This can be done with the Do Not Disturb function.

1 Open the **Settings** app and drag the **Do Not Disturb** button **On**

2 Tap once on **Notifications**

3 Tap once on this link

4 Drag the **Scheduled** button **On**, to specify a time period for when you do not want to be disturbed. Tap on the **From/To** link to set the required times

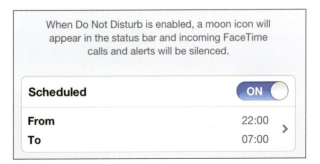

When Do Not Disturb is enabled, a moon icon will appear in the status bar and incoming FaceTime calls and alerts will be silenced.

Scheduled	ON
From	22:00
To	07:00

5 Tap once on the **Allow Calls From** link to specify exceptions to Do Not Disturb

6 Select options for allowing calls (**Favorites** can be set for contacts in the **Contacts** app)

25

7 Drag the **Repeated Calls** button to **On** to enable two, or more, FaceTime calls not to be silenced so that people can contact you in this way in an emergency

8 When Do Not Disturb is activated, a half-moon appears at the top of the screen at the point where the Notification Center is accessed

🌙 13:54

Looking around, in 3D

One of the innovative features in the **Maps** app for
iOS 6 gadgets is the Flyover function. This enables you
to view locations in 3D relief, as if you were moving over
them from above. You can also zoom in and change the
perspective. To use Flyover:

1 Access a map and view it in
Standard view

2 Swipe in from the bottom right-hand
corner and tap on the **Satellite**
button

3 Tap once on this button to activate the **Flyover**
functionality (if available for the area being viewed)

4 The perspective changes so
you are viewing the map from
an angle and in 3D.
(Drag around on the map to
move through the location as
if you were flying over it)

Finding your way

Finding your way around is an important element of using maps and this can be done with the **Directions** function:

1 Tap once on the **Directions** button and enter a **Start** and **End** destination location or address

2 Tap once on the **Route** button on the keyboard (or at the top of the Directions window)

3 The route is shown on the map. Tap once on the **Start** button to get directions

Start

4 The route is shown on the map with directions for each section

5 Swipe to the left and right to view the next, or previous, set of directions for the route

It's a page turner

There is a range of productivity apps in the App Store that cover word processing, spreadsheets and presentations. The suite is known as iWork and there are versions for Mountain Lion and iOS 6 – items created in one version can be opened and edited in other versions too. The word processing app is called Pages. To use it:

1 Locate and download the **Pages** app in the App Store

2 Documents can be created based on pre-designed templates

3 Documents created with Pages can be shared between gadgets using iCloud. When opening documents, click or tap on the **iCloud** button to see the available items

Got your number

Numbers is the spreadsheet app within the iWork suite. This can be obtained in the same way as the Pages app and it can be used to create spreadsheets for a number of functions, such as keeping household accounts and school projects. To create spreadsheets with Numbers:

1 Locate and download the **Numbers** app in the App Store

2 Spreadsheets can be created based on pre-designed templates

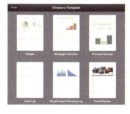

3 Enter text and figures into the spreadsheet by clicking or tapping on a cell and entering the required item

4 Use the **Function** option to perform calculations for groups of figures, e.g. create the sum of a column of figures. You can also enter your own formula into a cell in the spreadsheet

5 The formula performs the required calculation in the cell into which it is entered

Brushing up your presentation

Powerpoint is the well-known presentation app for Windows computers. The equivalent for Apple gadgets is the Keynote app. This can be used to create presentations with numerous slides, containing text and images. Transitions can also be added between slides.

1 Locate and download the **Keynote** app in the App Store

2 Presentations can be created based on pre-designed templates

3 Each slide is based on the template. Click on the designated areas to enter text and images

4 Use the **Build** function to create animated effects for how new items appear on a slide once it is viewed as a presentation. This can be text blocks or images

3 Picture this

The iOS 6 gadgets (iPad, iPhone and iPod Touch) all have cameras which can be used to capture both photos and videos. This chapter shows how to best use the camera and also how to edit, organize and share photos, and videos, across all Apple gadgets.

Getting close-ups

The cameras on the iOS 6 gadgets (iPad, iPhone and iPod Touch) may not have the full functionality of dedicated digital cameras, but they can capture high resolution photos and they also have good quality lenses in the cameras. In addition to taking standard view photos, it is also possible to zoom in on items to make them appear larger. To do this:

1 Open the camera by tapping on this icon

2 View a subject in standard 1:1 view

3 Pinch outwards with thumb and forefinger to zoom in on the subject (on some gadgets this is only for the front-facing camera, if there are two)

Shifting focus

Another feature of the camera on iOS 6 gadgets is the ability to change the area of focus in an image. This means that you do not always have to focus on the middle of the image. When you change the area of focus, this also becomes the area where the exposure for the photo is taken, i.e. the measurement of light for the correct exposure. To do this:

1 Tap on the screen to set that area as the point of focus

2 If you move the camera the point of focus (and exposure) will change as the camera auto-focuses

Don't forget

Cameras on iOS 6 gadgets have a face recognition feature for focusing whereby they will track and focus on faces in a shot.

Instant composition

Taking the time to compose photos as well as possible can make the difference between an average snapshot and a great photo.
One technique that is used for composition is known as the Rule of Thirds, where a grid is used to position the subjects in the frame.
On iOS 6 gadgets there is a function to superimpose this type of grid within the Camera app.

1 Open the **Camera** app and tap on this button

2 Drag the **Grid** button **On**

3 Use the grid to position subjects in the frame. They can be positioned in the different segments, or at the intersection of the grid lines

Paddling in the Photo Stream

The Photo Stream is the part of iCloud that makes your photos available on all of your Apple gadgets. To enable this, first make sure that iCloud is set up:

1 Access **iCloud** from either **System Preferences** (Mountain Lion) or **Settings** (iOS 6)

2 Check on the **Photo Stream** option or tap on the link in iOS 6

3 For iOS 6, drag the button to **On**

Viewing the Photo Stream

Photos are added to the Photo Stream in two main ways:

1 Take a photo on an iOS 6 gadget with this button, or

2 Import photos into iPhoto on a Mountain Lion computer

3 Click on the **Photo Stream** button in iPhoto, or tap on it on an iOS 6 gadget to view the photos

4 The photos in the Photo Stream should be the same on all gadgets

Deleting photos from the Photo Stream

Photos can be deleted from the Photo Stream, from any gadget. This removes it from the Photo Stream on all other gadgets, but it does not delete it from where it was originally created.

1 Select a photo in the Photo Stream

2 Tap on this button (iOS 6) or press the back delete button (Mountain Lion)

3 Tap on the **Delete Photo** button, or click on **Delete** to remove the photo from the Photo Stream (but it remains in its original location)

Sharing with the Photo Stream

The Photo Stream option can be used to share photos with other people, using the Photo Stream Sharing function, from either the **Photos** app on iOS 6 gadgets or **iPhoto** in Mountain Lion. To use this:

1 Select a photo you want to share via Photo Stream

2 Tap on the **Share** button

3 Tap on the **Photo Stream** button

4 Tap on the **New Photo Stream** button

5 Enter a recipient with whom you want to share the Photo Stream and enter a name for it

6 Tap on the **Next** button in Step 5 and enter a comment about the Photo Stream. Tap once on the **Post** button

7 The recipient receives an email inviting them to view the shared Photo Stream. If they click on the **Join this Photo Stream** they will be taken to an iCloud page to view the photos

Editing photos

All Apple gadgets can be used to edit photos: the Photos app can be used on iOS 6 gadgets and iPhoto can be used with Mountain Lion computers. There is also a version of iPhoto for iOS 6 gadgets that can be downloaded from the App Store.

Editing with iPhoto on Mountain Lion

iPhoto is primarily an app for organizing and sharing photos but it can also be used for some editing tasks:

1 Open **iPhoto** by clicking on this icon

2 Import photos into iPhoto by connecting a digital camera, a memory card, pen drive or by importing them from your computer

3 Select a photo and click on the **Edit** button

4 Click on the **Quick Fixes** tab and select one of the editing options

Beware

The iPhoto apps for iOS 6 gadgets and Mountain Lion have to be bought separately.

5 Click on the **Effects** tab and select one of the editing options. These are applied automatically

6 Click on the **Adjust** tab and select one of the editing options

7 Drag the sliders to apply the editing changes for each function

39

8 Click on the **Revert to Original** button to undo all of the editing changes that have been made, or click on the **Edit** button to accept them

Hot tip

Use the **Exposure** option in the **Adjust** section to brighten or darken a photo.

Editing with Photos on iOS 6 gadgets

The Photos app can be used for some basic editing functions on iOS 6 gadgets. To do this:

1 Open **Photos** by clicking on this icon

2 Select a photo and tap on the **Edit** button

3 Tap on the **Rotate** button to rotate the photo 90 degrees anti-clockwise

4 Tap on the **Enhance** button to have auto color enhancements applied

5 Tap on the **Red-Eye** button and tap on an area with red-eye to remove it

6 Tap on the **Crop** button and drag the grid on the screen to crop the current photo

7 Tap on the **Undo** button to reverse the latest action and the **Revert to Original** button to reverse all changes

8 Tap on the **Save** button to save the changes

Editing with iPhoto on iOS 6 gadgets

The iOS 6 version of iPhoto has a wider range of editing tools than the Photos app and it is an excellent option if you want to perform a lot of editing of photos on your iOS 6 gadgets. To use this version of iPhoto:

1 Locate and download **iPhoto** from the App Store

2 When you open iPhoto it will import all of the photos that are currently in the Photos app

3 Use these tools to, from left to right, crop and straighten, adjust exposure, adjust color, use effects brushes and apply special effects

4 Tap on the **Effects Brushes** and select one of the options

5 Tap on the **Special Effects** option and select one of the color effects

41

Adding albums

As you add more and more photos to your Apple gadgets you may want to organize them into albums. This is a good way of sorting them according to subject or content type, so you can then find specific photos more quickly. To create albums:

iPhoto

1 In iPhoto on Mountain Lion, click on the **Create** button and select the **Album** option

2 Enter a new name for the album

3 Photos can be added to the album by dragging them from the main Library

4 Albums can also be created by selecting one or more photos and clicking on the **Add To** button

5 Click on the **Album** button to create a new album as above. Or, click on an existing album to add the photo(s) to it

Photos app

1 In **Photos** on an iOS 6 gadget, tap on the **Albums** tab

2 Tap on the **Add** button

3 Enter a name for the album and tap on the **Save** button

New Album

Enter a name for this album.

Nature

Cancel Save

43

4 To add photos to an album, tap on the **Edit** button and tap on the **Add Photos** button

Add Photos

5 Tap on the required photos to select them and tap on the **Done** button to add them to the album

Getting creative

Apps for working with digital photos tend to be easy to use and, most importantly, fun. A lot of apps specialize in special effects so that you can quickly turn your photos into works of art. One of these is PhotoFunia which can be used for a variety of special effects.

1 Download and install **PhotoFunia** from the App Store

2 Select an effect

3 Tap on the **Choose Photo** button

4 Select whether to use a photo from your existing ones or take a new one with the camera

5 Tap on the **OK** button to save the photo effect

OK

4 Music to your ears

Apple gadgets are ideal for downloading and playing music. The original iPod helped to revolutionize the way we listen to music and this has continued with the unstoppable march of iTunes and the Music app for playing and organizing music, and the iTunes Store for downloading it. This chapter looks at some ways in which you can fully enjoy your musical experiences on Apple gadgets.

Creating a playlist

One music option on Apple gadgets is to create playlists of your music,
so that you can organize all of your favorite tracks, or types of music,
together. On Mountain Lion computers this is done with iTunes and on
iOS 6 gadgets the Music app performs the same task. To do this:

1 Open **iTunes** or the **Music** app (the iTunes app on iOS 6
gadgets opens the iTunes Store)

2 Tap on the **Playlists** button (iOS 6) or click on
this button (Mountain Lion)

Playlists

+

3 Tap on the **New** button (iOS 6)

New

4 Enter the name for the playlist
(tap on **Save** on iOS 6)

🎵 untitled playlist

New Playlist

Enter a name for this playlist.

Summer

Cancel Save

Don't forget

Once playlists have been created they are available via iTunes
and the Music app and can be download onto iPods too.

Adding songs to a playlist

Once a playlist has been created, songs can be added to it in the
following ways:

1 For Mountain Lion computers, select the
songs in your music library

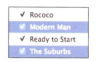

2 Drag them onto the playlist name
to add them

3 For iOS 6 gadgets, open the playlist
and tap the **Add Songs** button. Tap on songs to add them

4 Tap on the **Add All Songs**
button to add all of the songs
in your library to the playlist. Tap on the **Done** button

Hot tip

To select items as in Step 1, click on the first item to select it,
then hold down the **cmd** (Apple) button and select another,
non-consecutive, item. Hold down **Shift** to select consecutive
items.

Being a record producer

You do not have to play music on your Apple gadgets with the default settings all of the time. For anyone who wants to try their hand at a bit of music production there are a few controls that can be used for this:

Sound Check

Not all music is recorded at the same volume, but this option enables you to play it at the same level. To do this on iOS 6 gadgets:

1 Access the **Music** option in **Settings**

2 Drag the **Sound Check** button to **On**

On Mountain Lion computers:

1 Open iTunes and select **iTunes > Preferences** from the menu bar

2 Click on the **Playback** button to access these preferences

3 Check on the **Sound Check** box

Additional sound settings

As well as the Sound Check option there are also other ways in which music on Apple gadgets can be manipulated. On Mountain Lion computers:

1 Access the **Playback** preferences as on the previous page

2 Check on the **Crossfade Songs** option to enable songs to blend into each

other when they finish and start. Check on the **Sound Enhancer** option to allow iTunes to improve the overall quality of music

On iOS 6 gadgets:

1 Access the **Music** option in **Settings**

2 Tap on the **EQ** (Equalizer) button

3 Make a selection for the way you want the music to be enhanced. This will apply to all of the music played by the Music app

Becoming a Genius

It is always nice to get some suggestions about new music, particularly if it is based on items that you have previously bought. For Apple gadgets, this is done with the Genius feature in iTunes.

1 On Mountain Lion computers, open iTunes and click on this button (or select **Store > Turn On Genius** from the menu bar)

2 Click on the **Turn On Genius** button

3 Sign in with your Apple ID (this is required because the Genius function sends information about your iTunes library to Apple. Although it is anonymous, an Apple ID is still required to verify this)

Once Genius has been turned on it can be used in a number of ways:

1 Select a song in
your iTunes library

2 Click on this button to create a Genius playlist.
This is a playlist from your library based on what
Genius calculates are similar types of songs

3 The iTunes
Store homepage
has a list of
recommendations
for you, based on
previous purchases

4 For iOS 6 gadgets, access the iTunes Store
and tap on this button to view Genius
recommendations

Don't forget

On iOS 6 gadgets, the iTunes Store is accessed from either the
iTunes app or the **Store** button from within the **Music** app.
If Genius in iTunes on a Mountain Lion computer is turned **On**
the range of recommendations will be more extensive.

Sharing at home

If you have more than one Apple gadget it is convenient to be able to share content between gadgets, without having to copy it onto both. With iTunes and the Music app this is possible for music with the Home Sharing function. This makes all of your music available between gadgets, even if you have not initially downloaded it from the iTunes Store. To set up Home Sharing for music.

1 On Mountain Lion computers, open **iTunes** and select **Advanced > Turn On Home Sharing**

2 Enter your Apple ID details, as these are required for Home Sharing

3 Click on the **Done** button. This makes Home Sharing available on other gadgets set up for this

4 On an iOS 6 gadget, access the **Music** option in the **Settings** app

5 Enter your Apple ID details, as in Step 2, under **Home Sharing**

Home Sharing	
Apple ID	nickvandome@mac.com
Password	••••••••

An Apple ID is required to use Home Sharing.

6 Open the **Music** app

7 Tap on the **More** button and tap on the **Shared** link

More

🏠 Shared >

🎵 Genres

🎼 Composers

Sort By Artist ◯ OFF

Music is sorted alphabetically by title.

_bums More

More **Shared**

My iPad

Nick Vandome's Libr... ✓

bums More

8 Tap on the link to the item you want to share

Beware

If you turn off the gadget from which the library is being shared it will no longer be available on the other gadgets. All gadgets also have to be connected to a Wi-Fi network.

Syncing an iPod

The iPod is one of the most iconic products of the 21st century. It has transformed the way we listen to music, both in the home and on the move. When you attach an iPod to a computer with iTunes, the music can be downloaded to the iPod. This can be done automatically, in which case all of the music will be downloaded (or as much as the iPod can hold). However, if you are connecting your iPod to different gadgets you may not want it to sync each time, as this would overwrite the existing content. To ensure that your iPod is only updated manually:

1 Attach the iPod to a Mac computer with iTunes. It will be displayed in the sidebar. Click on its name

2 Check on the **Manually manage music** box in the main window

3 Access the **iTunes Preferences**, as shown on page 48, and click on the **Devices** button

4 Check on the **Prevent iPods, iPhones, and iPads from syncing automatically** box

Don't forget

Music on iPads can be synced in the same way as an iPod, and it can also be done with Wi-Fi, see page 56.

5 If you want to sync the iPod automatically, tap on the **Music** tab and check on the **Sync Music** box

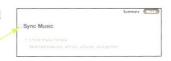

6 A dialog box warns that if you sync music to the iPod it will replace anything already there. If this is what you want to do, click on the **Sync Music** button

7 To add music to an iPod manually, select songs in the main library and drag them over the iPod name in the sidebar

8 As the iPod is being updated, this is indicated at the top of the iTunes window

Syncing over Wi-Fi

iPads can be synced with a Mac computer in the same way as an iPod, i.e. by connecting it via USB with its supplied cable and then syncing its content. This can also be done over Wi-Fi without the need for a cable:

1 Attach the iPad to the computer (with the cable at this stage) and click on its name in iTunes

2 Under **Options** in the main window, check on the **Sync with this iPad over Wi-Fi** box

3 Click on the tabs at the top of the window to select which items you want to be synced

4 On the iPad, select the **General** option in the **Settings** app

5 Tap on the **iTunes Wi-Fi Sync** link

6 The iPad will be synced automatically when the Mac computer is on, but it can also be synced manually by tapping on the **Sync Now** button

5 There's an app for it

Apps from the Apple App Stores have helped to change the computing landscape: both in terms of functionality and also terminology. The word 'app' is becoming widely used instead of the former 'program' and there are apps for almost anything you want to do: from high-powered productivity tasks to entertaining games. This chapter looks at obtaining and installing apps on Apple gadgets and how you can use them to enhance your digital experience.

Creating your collection

Although the apps in the App Store for Mountain Lion and iOS 6 gadgets are slightly different, they are all accessed, located and downloaded in the same way.

1 Click or tap on the **App Store** icon

2 Click or tap on this button to view the latest featured apps, as chosen by the App Store

3 Click or tap on this button to view the top selling apps, for paid-for and free apps

4 Click or tap on this button to search for apps according to categories such as Business, Health & Fitness, Productivity and Sports

5 Click or tap on this button to view apps that you have already downloaded

The links in the steps here are located at the top of the screen on Mountain Lion computers and at the bottom of the screen for iOS 6 gadgets. iOS 6 gadgets also have buttons for All Categories, Games, Education, Newsstand and More.

6 Click or tap on this button to view updates for your existing apps (if updates are available this is indicated by a number on the button)

7 Enter a word in the **Search** box to find a specific app

Downloading apps

Apps can be previewed and then downloaded:

1 Click or tap on an app to view its details

2 Click or tap on this button to download an app (if it is paid-for it will have a price)

3 The app downloads to your Launchpad/Home screen

4 Click or tap on an app to open it and start using it

An Apple ID is required to download apps from the App Store. For paid-for apps, you have to have credit/debit card details linked to your Apple ID.

Sharing apps

Details about apps can also be shared with people in a number of ways:

1 In the App Store access
the app you want to share
and click or tap on the
Share button

2 Select one of the sharing
options including, **Mail**,
Message, **Twitter** or
Facebook

3 Details about the app
are added to the sharing
method selected in Step 2,
i.e. a **New Message** in
the **Mail** app

Updating apps

The world of apps is a dynamic and fast-moving one and new apps are being created and added to the App Store on a daily basis. Existing apps are also being updated, to improve their performance and functionality. Once you have installed an app from the App Store it is possible to obtain updates, at no extra cost (if the app was paid-for). To do this:

① When an update is available it is denoted by a red icon on the App Store button, showing how many updates are available. Click or tap on the **App Store** button

② In the App Store, click or tap on the **Updates** button

③ The available updates are displayed

④ Click or tap on the **Update** button next to an app to get the latest version

⑤ Click or tap on the **Update All** button to update all of the apps at once

Cleaning up your apps

When you start downloading apps you will probably soon find that you have dozens, if not hundreds, of them. You can move between screens to view all of your apps by swiping left or right.

As more apps are added it can become hard to find the apps you want, particularly if you have to move between several screens. However, it is possible to organize apps into individual folders to make using them more manageable. To do this:

1 Click and hold (Mountain Lion) or press and hold (iOS 6) on an app until it starts to jiggle and a white cross appears at the top-left corner

2 Drag the app over another one

3 A folder is created, containing the two apps

4 The folder is given a default name, usually based on the category of the apps

5 Click or tap on the folder name and type a new name as required

6 Click on the screen (Mountain Lion) or click the **Home** button (iOS 6) once to finish creating the folder

7 The folder is added within the Launchpad (Mountain Lion) or the Home screen (iOS 6). Click or tap once on this to access the items within it

Pausing and deleting apps

Pausing apps

When you are downloading apps this can use up some of the processing power of your Apple gadget. If you are performing other tasks you can pause the download while you are completing something else.

1 Locate your downloading app on the Home screen (iOS 6) or in the Launchpad (Mountain Lion)

2 Click or tap on the app to pause the download. Click or tap on it again to resume

Deleting apps

If you decide that you do not want certain apps anymore, they can be deleted from your gadgets. However, they remain in the iCloud so that you can reinstall them if you change your mind. To delete an app:

1 Press on an app until it starts to jiggle and a white cross appears at the top-left corner

2 Click or tap on the white cross to delete the app. In the Delete dialog box, click or tap on the **Delete** button

6 It's all happening online

It is becoming increasingly difficult to differentiate between our online lives and our offline ones. This chapter shows how to combine the two, by organizing your emails, updating your social media and sharing your photos, videos and ideas.

Inviting VIPs

In the Mail app there is a VIP mailbox, which can be used to store emails from your favorite contacts. To set this up:

1 When you get an email from someone you want to specify as a VIP, tap and hold on their name in the email header (or tap on the VIP mailbox and tap on the **Add VIP** link)

2 Tap on the **Add to VIP** button

3 Messages from VIPs are identified by a star next to them

4 Tap on the **VIP** mailbox link to see the messages from all of your VIPs

Signing off in style

We all have our own unique signature when we sign a letter and now the same can be true for our online correspondence. On iOS 6 gadgets you can personalize the signature that appears at the end of your emails:

1 Access the **Mail, Contacts, Calendars** option in the **Settings** app

2 Tap on the **Signature** link (under the **Mail** section)

3 The default signature is displayed

4 Overwrite the signature as required, to create your own

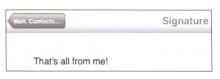

personalized sign-off (this will appear automatically at the bottom of all of your emails, so you may want to amend it for different types of correspondence)

Hot tip

Signatures can also be set in the Mail app on Mountain Lion computers. To do this, select **Mail > Preferences** from the menu bar and click on the **Signatures** tab in **Preferences**.

Adding mailboxes

It is common to get several different types of emails: from family, friends, business contacts, online bookings and miscellaneous. Many of these you will want to keep for reference and the best way to do this is to create different mailboxes in which they can be stored. To do this:

1 In Mail on a Mountain Lion computer, click on this button and select **New Mailbox**

2 Select the location for the mailbox (this will be iCloud or On My Mac), give the mailbox a name and click the **OK** button

3 In the Mail app on an iOS 6 gadget, tap on the **Mailboxes** button

4 Tap on the **Edit** button

5 Tap on the **New Mailbox** button

6 Specify a name and location and tap on the **Save** button

Quick delete emails

One of the drawbacks about the connected world is the number of emails that we can receive on a daily basis. Even without the scourge of spam emails, it is easy for your Inbox to become swamped with updates, invitations, questions and queries. It can be time-consuming to sort through all of them, but it is possible to delete them quickly.

1 On a Mountain Lion computer, hold down **ctrl** and click on the email. Click on **Delete** from the menu that appears

2 On an iOS 6 gadget, swipe to the right on the email and tap on the **Delete** button

3 On Mountain Lion computers it is also possible to put unwanted emails straight into your junk folder. Select the email and click on the **Junk** button on the Mail toolbar. After a while Mail will become trained about what is junk mail and remove it automatically

Hot tip

When emails are deleted they are placed in the Trash Mailbox. To empty this, select **Mailbox > Erase Deleted Items** on a Mountain Lion computer or open the mailbox on an iOS 6 gadget, select **Edit** and delete the required items.

Adding photos

Adding photos and videos to emails is a great way to bring them to life and with iOS 6 gadgets this can be done directly from an email, without having to open another app:

1 Press and hold in the body of an email so that the toolbar appears

2 Tap on the **Insert Photo or Video** button

3 Tap on one of the albums from which to select a photo or video

4 Select a photo or video and tap on the **Use** button to include it in the body of the email

Setting email sounds

For iOS 6 gadgets it is possible to set sound alerts for when emails (and other items) arrive and also specify different sounds for emails from VIPs. To do this:

1 In the **Settings** app, tap on the **Sounds** button

2 Select an item for a sound alert, such as **New Mail**

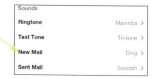

3 Tap on an alert sound to select it

4 To set a different alert sound for VIP emails, tap on the **Notifications** button in the **Settings** app and tap on the **Mail** button

5 Tap on the **VIP** link to select alert settings, including **New Mail Sound,** for email VIPs

Instant status updates

Facebook is one of the social revolutions of the 21st century. It has grown into a communications tool used by hundreds of millions around the world and for a lot of people it is now an indispensable part of everyday life. Now it is possible to update your Facebook status directly from an Apple gadget. To do this:

1 Configure a Facebook account (**Settings > Facebook** on iOS 6, **System Preferences > Mail, Contacts, Calendars** on Mountain Lion)

2 Select the item you want to add to your Facebook status

3 Click or tap on the **Share** button

4 Click or tap on the **Facebook** button

5 Enter a message to go with the status and click or tap on the **Send** button

Don't forget

Facebook and Twitter (see next page) updates can also be set to appear in the Notification Center.

Tweet, tweet

Twitter is another social media tool that feeds our growing addiction for being in contact with the world on a 24/7 basis. It consists of posting short (140 character) messages, known as tweets, to your Twitter page. Other people can then follow your Twitter feed, as you can with others. With Mountain Lion and iOS 6 you can post items to Twitter without having to leave the comfort of your Apple environment. This can be done to tweet photos and web links, to which you can add comments.

1 Select the item you want to tweet (web links can be tweeted from Safari, in which case the link is included in the tweet)

2 Click or tap on the **Share** button

3 Click or tap on the **Twitter** link

4 You need to have a Twitter account set up (twitter.com) and this then needs to be added to your Apple gadget. This only needs to be done once for each Apple gadget

5 Enter a message to go with the tweet and click or tap on the **Send** button

Sharing from Notifications

The Share Widget, or button, can be used so that items can be shared to Facebook and Twitter directly from the Notification Center. To do this:

① In **System Preferences** or the **Settings** app, click or tap on the **Notifications** button

② Tap on the **Share Widget** link (or check on the **Show share button in Notification Center** for Mountain Lion)

③ Drag the **Notification Center** button to **On**

④ In the Notification Center, tap, or click, on the button(s) at the top to post to the required service

⑤ Enter your message and click or tap on the **Send** button

7 Going on Safari

The Apple web browser, Safari, takes the browsing experience to new levels. This chapter looks at Safari and shows some handy things to do with it, such as saving images, following links, navigating around with tapping and pinching and making the most out of working with tabs. Once you have mastered some of these tips it may be the most satisfying Safari you have been on.

Following links

Links (or hyperlinks) on a web page are routes to other sites and pages on the web. They can be activated by clicking or tapping on them and they open the linked page in the current window. However, there are other ways to work with links too:

1 On an iOS 6 gadget, press and hold on a link. Select one of the options for what you want to do with the link, including opening it in a new tab, adding it to the Reading List to view offline or copying the link

2 Depending on the new tab settings (see next page) the link can open as a new tab, without moving from the current window

3 On a Mountain Lion computer, hold down the **cmd (Apple)** key and click on the link. As above, this opens in a new tab

Don't forget

If you activate a link in Step 1 on an iOS 6 gadget, the address of the linked web page is shown at the top of the window.

New tab settings

When you activate a link on a web page there are various settings for the way in which the linked page opens. One of these is to open it as a new tab in the background. This means that a new tab is created with the linked content, but you do not move away from the page that you are currently viewing. The new page can then be viewed when you want. To set new tabs in the background:

1 On an iOS 6 gadget, access the **Safari** option in the **Settings** app

2 Drag the **Open New Tabs in Background** button **On**

3 On a Mountain Lion computer, select **Safari > Preferences** from the Safari menu bar

4 Click on the **Tabs** button

5 Check on this box. This works by holding down the **cmd (Apple)** key and clicking on a link

6 Other options are available in the **Tabs Preferences**

Sharing tabs

If you have more than one Apple gadget it can be frustrating if you are looking up something on the Web on one gadget and then have to find and open it again if, at a later date, you want to look at the same page on another gadget. Luckily, with Safari there is a function for sharing tabs between gadgets:

1 Open a web page on one gadget (you can also open pages on additional tabs)

2 On another gadget, open **Safari** and click or tap on this button

3 All of the tabs that are open within Safari on other Apple gadgets are displayed

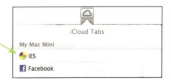

4 Click or tap on an item to open it on the current gadget

Adding tabs

Tabs are now a common part of web browsing: new tabs can be created so that you can have a lot of web pages open within the same window. You can move to each page by clicking or tapping on the relevant tab. To add new tabs:

1 For all gadgets tap on this button within Safari

2 On iOS 6 gadgets, new tabs open as **Untitled** pages. Access a new page from the Bookmarks Bar or by entering a web address into the Safari Address Bar

3 On Mountain Lion computers, new tabs can be opened with the **Top Sites** window. This contains your most frequently-visited sites. Click on one of these to open it or enter a web address as above

Hot tip

For Mountain Lion computers, the way new tabs are opened can be specified by selecting **Safari > Preferences** from the menu bar. Click on the **General** button and make selections within the **New tabs open with** option.

Saving images

Images play a pivotal role on the Web; without them it would be a much less engaging medium. If you see an image you would like to use for something it is possible to download it to your Apple gadget.

1 On an iOS 6 gadget, press and hold on the image. Tap on the **Save Image** link to save it to the **Photos** app. Tap on the **Copy** link to copy it so that you can then paste it somewhere else

2 On a Mountain Lion computer, hold down the **ctrl** key and click on an image. Select one of the save options

Beware

If you download images from web pages, do not use them for any commercial purposes.

Tap, tap, swipe

Apple gadgets have embraced, and in some cases led the way, with multi-touch gestures. These are ways of navigating around the screen using tapping and swiping gestures on the screen of an iOS 6 gadget, or with a trackpad, Magic Trackpad or Magic Mouse on a Mountain Lion computer. Multi-touch gestures were initially developed on the iPhone, iPad and iPod Touch and these have since been adopted by Mountain Lion computers such as the iMac and MacBooks.

Tapping and swiping gestures work on web pages and they also work on a lot of other content such as photos, maps and some documents.

Swiping up and down

Swipe up and down with two fingers on Mountain Lion computers, or one finger on iOS 6 gadgets, to move up or down web pages, photos, maps or documents. The content moves in the opposite direction of the swipe, i.e. if you swipe up, the page will move down and vice versa.

Tap to zoom

Double-tap with one finger on iOS 6 gadgets, and two fingers on Mountain Lion computers, to zoom in on a web page, photo, map or document. Double-tap with two fingers to return to the original view.

Pinch yourself

Pinching is another technique that can be used to navigate around web pages (and also other content). This can be done on an iOS 6 gadget and also a Mountain Lion gadget with a trackpad or Magic Trackpad.

Pinch and swipe outwards with thumb and forefinger to zoom in on a web page, photo, map or document.

Pinch together with thumb and forefinger to zoom back in on a web page, photo, map or document.

Finding on a page

Modern web pages can hold huge amounts of information and it can sometimes be a challenge to find specific items on a page. One solution to this is the Find on Page function. To use this:

1 On an iOS 6 gadget, tap open **Safari** and tap on the search box at the top

2 Enter a search word or phrase in the **Find on Page** box

3 The first instance is highlighted on the page

4 Tap on these buttons to find all instances on the page

5 On a Mountain Lion computer, select **Edit > Find > Find** from the Safari menu bar

6 Enter a search word or phrase in the **Find on Page** box

7 The word is highlighted as for an iOS 6 gadget. Click on the buttons next to the search word to view all of its instances, as in Step 4

Power on location.
The processor, graphics, and memory inside the all-new MacBook Pro are built around an all-flash architecture — giving you unprecedented mobile video editing capabilities. Super-responsive flash storage delivers up to nine streams of 1080p ProRes (HQ) content for multicam editing in Final Cut Pro X,³ while the latest quad-core processors decode multiple streams of video and a powerful GPU renders millions of pixels onto the screen. With flash storage that offers up to four times the performance of a traditional hard drive,¹ you can even edit four streams of uncompressed 8-bit 1080p HD video right from your internal storage.⁴

Saving it for later

It is sometimes thought that we always have to be connected and online to read pages on the web. Since this is not always possible it is useful to have the ability to save web pages so that they can be read at a later time and without the need for an Internet connection. On Apple gadgets, Safari solves this issue with the Reader function.

1 On a Mountain Lion computer open the web page you want to read later and click on this button

2 Click on the **Add Page** button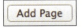

3 The page is added to the Reading List. This will be available even when you are offline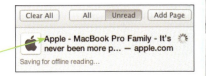

4 On an iOS 6 gadget, tap on the **Share** button and tap on the **Add to Reading List** button

5 Tap on the book icon and the button in Step 1 to view the Reading List items. These will include any that have been added from other Apple gadgets

8 At your fingertips

The virtual keyboard on Apple gadgets such as the iPad, iPhone and iPod Touch can come as a bit of a shock to anyone used to a more traditional type of computer keyboard. But with a bit of practice you will soon be using it like an expert. This chapter details how to find extra items on the keyboard, split it on the screen and how to add and edit text.

Extra punctuation keys

The keyboard on iOS 6 gadgets is a touchscreen one that contains most of the functionality of a traditional QWERTY computer keyboard. There are a few basic operating functions for the keyboard and also some useful punctuation shortcuts that can be used.

1 Tap on the **Numbers** and **Special Characters** buttons to access additional keys

2 Tap on the **Shift** button for a capital. Tap and hold on it for **Shift Lock**

3 Double-tap on the spacebar to add a full stop/period and a space at the end of a sentence

The end.

4 Swipe up once on the comma (or press and hold) to insert an apostrophe

5 Swipe up once on the full stop/period (or press and hold) to insert quotation marks

6 Tap on the **Numbers** button. Press and hold on the full stop/period button to insert an ellipsis

7 Tap on this button to hide the keyboard

Finding hidden keys

Because of its size, there are certain constrictions to the iOS 6 keyboard. This is largely overcome by hiding certain letters and symbols behind other keys. This is the case for accented letters that are used when creating words in different languages. It is also possible to add numbers quickly without the need to constantly toggle between the letters and numbers keyboards.

Finding accents
To find the hidden accent keys:

1 Press and hold on appropriate letters to access accented versions for different languages

Adding quick numbers
It can be annoying to have to toggle between the numbers and letters keyboards when you want to add numerals. Instead a quick way to do this is:

1 Tap and hold on the **Numbers** button

2 Without removing your finger, drag up to the number you want to add. This will be added and you will be returned automatically to the letters keyboard

Splitting the keyboard

The iPad keyboard can also be split into two and used on either side of the screen. However, this cannot be done on the iPhone or the iPod Touch as it would make the keyboard too small to use realistically. The iPad keyboard can be split from a button on the keyboard or manually with two fingers.

Split button
To use the Split button:

1 Press and hold here on this button on the keyboard

2 Tap once on the **Split** button

3 The keyboard is split to the left and the right sides of the screen

4 Tap here to enter the letter on the opposite side of the split keyboard. For instance, tap here to add a Y at the end of a word

Splitting manually

To split the keyboard manually:

1 Swipe in opposite directions with one finger on each side of the keyboard, as if you are tearing it apart

Moving and restoring the keyboard

To move the keyboard and then restore the keyboard to its default state:

1 Tap and hold here to move the split keyboard

2 Drag the keyboard into its new position

3 Tap and hold here and tap on the **Dock and Merge** button to restore the keyboard, or

4 Swipe inwards with one finger on each side of the keyboard to merge it (it will still have to be docked at the bottom of the screen by dragging it there as in Step 2)

Working with text

Once text has been entered with an iOS 6 keyboard it can be selected, and edited in a number of ways. Depending on the app being used, the text can also be formatted, such as with a word processing app.

Selecting and editing text

To select text and perform editing tasks on it:

1 To change the insertion point, tap and hold until the magnifying glass appears

2 Drag the magnifying glass to move the text insertion point

3 Tap at the insertion point to access the selection buttons

4 Double-tap on a word to select it. Tap on **Cut** or **Copy** as required

5 Drag the selection handles to expand or contract the selection

91

6 If text has been copied, tap and hold at a new point on the page and tap on **Paste**

Hot tip

Double-tap on a word for the **Define** option. Tap on this to view a dictionary definition of the selected word. Double-tap on a misspelled word to view alternatives via the **Suggest** button.

Quick undo

The undo function on computers can be an invaluable one: it is a great way to reverse any typing mistakes, or if you have had a change of mind about what you have just done. On iOS 6 keyboards there are a couple of ways to perform the undo function:

1 Shake the iOS 6 gadget vigorously from side to side

2 Tap on the **Undo Typing** button, or

1 On the keyboard, tap on the **Numbers** button

.?123

2 Tap on the **undo** button

undo

Don't forget

The undo function can be used on Mountain Lion computers by pressing **cmd + Z** on the keyboard.

Emojis at your fingertips

They go by a variety of names (smileys, emoticons, emojis) and tend to split opinion along the lines of, 'silly nonsense' or 'great fun'. Whatever your views on them, it is possible to use a wide range of emojis on iOS 6 gadgets. To do this:

1 Access the **General** section in the **Settings** app

2 Tap on the **International** link

International >

3 Tap on the **Keyboards** link

Keyboards 1 >

4 Tap on the **Add New Keyboard** link

Add New Keyboard... >

5 Select the **Emoji** option. This will now be added as an option to the keyboard

Emoji

6 On the keyboard, tap on this button (this gives access to additional keyboards)

7 Tap on the emojis to add them

We need to talk

On Apple gadgets there is a dictation option which enables you to enter text by speaking into a virtual microphone, rather than typing. This can be set up in the **System Preferences** for Mountain Lion computers and the **General** section within **Settings** for iOS 6 gadgets.

Dictation on Mountain Lion

To set up and use dictation on a Mountain Lion computer:

1 Open **System Preferences** and click on the **Dictation & Speech** button

2 Click on the **Dictation** tab and check this button. Enable dictation by selecting **Edit > Start Dictation** from an appropriate app

Dictation on iOS 6

To use dictation on an iOS 6 gadget:

1 Tap on this button on the keyboard to activate the dictation function and record

2 Speak the text you want to record. This is denoted by colored dots as it is being rendered

3 The text shows up in the relevant app

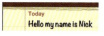

9 Good housekeeping

The practical tasks that can be performed on Apple gadgets may not always be the most fun of your digital life but they can be extremely useful in terms of keeping everything safe and up-to-date. This chapter looks at security issues such as passcodes and encryption, restricting access to certain types of content and finding your Apple gadgets if they are ever lost or stolen.

Saving power

In these energy conscious times it is important to try and save as much power as possible when using electronic equipment. Two options for this on Apple gadgets are limiting automatic email updates on iOS 6 and using energy saving settings on Mountain Lion computers.

Turning off Push updates

On iOS 6 gadgets it is possible to set emails to be 'pushed' automatically from the mail server. However, this uses up more energy on iOS 6 gadgets. To save energy this can be turned off:

1 Access the **Mail, Contacts, Calendars** option in the **Settings** app

 Mail, Contacts, Calendars

2 Tap on the **Fetch New Data** link

Fetch New Data Push >

3 Drag the **Push** button to **Off**

Push OFF

4 For Fetch settings for other gadgets, tap on the **Manually** option to save power

Fetch

The schedule below is used when push is off or for applications which do not support push. For better battery life, fetch less frequently.

Every 15 Minutes

Every 30 Minutes

Hourly

Manually ✓

Hot tip

Power can also be saved on iOS 6 gadgets by turning off **Wi-Fi** in the **Settings** app, when it is not needed for Internet access.

Energy settings

On Mountain Lion computers, energy settings can be used to save power when the computer is not in use. To do this:

1 Open the **System Preferences** and click on the **Energy Saver** button

2 Drag the sliders to specify a length of time until the computer and the monitor go to sleep when the computer is inactive

3 Check on this box to ensure the computer is put to sleep when inactive

4 For MacBooks there are energy saving options for when it is using a power adapter or its own internal battery

Hot tip

The screen brightness on iOS 6 gadgets can also be reduced, to save power. This is done with the **Brightness & Wallpaper** option in the **Settings** app.

Finding your gadgets

No-one likes to think the worst, but if your Apple gadget is lost or stolen, help is at hand. The Find My Mac/iPad/iPhone/iPod Touch function (operated through the iCloud service) allows you to send an alert to a lost Apple gadget and also remotely lock it or even wipe its contents. This gives added peace of mind, knowing that even if your gadget is lost or stolen its contents will not necessarily be compromised. To set up Find My Mac/iPad/iPhone/iPod Touch:

1 Access the iCloud settings (**Settings > iCloud** on an iOS 6 gadget, **System Preferences > iCloud** for Mountain Lion)

2 Drag this button to **On** to be able to find your gadget on a map and send messages to it remotely (for Mountain Lion, check on this option in the checkbox)

3 Click or tap on the **Allow** button to enable the **Find My iPad** (or appropriate gadget) functionality

Find My iPad
This enables Find My iPad features, including the ability to show the location of this iPad on a map.

Cancel Allow

Allow Find My Mac to use the location of this Mac?
Find My Mac is part of iCloud and helps you locate, lock, or erase a lost Mac.

Not Now Allow

Hot tip

There is also an iOS 6 Find My Friends app for locating people with iOS 6 gadgets, if they give you their details.

Finding a lost gadget

Once you have set up the Find functionality you can use it to find your gadgets through the iCloud service or by downloading the Find My iPhone app for iOS 6 gadgets. To do this:

1 Log in to your iCloud account at
www.icloud.com (for iOS 6 gadgets tap on
the **Install Find My iPhone** link to install this app)

2 Click on the **Find My iPhone** button (this also
works for other Apple gadgets)

3 Your gadgets are identified
and their current location is
shown on a map

4 Click or tap on the green
circle to access details for
the selected gadget

5 Click or tap on the **Play
Sound** button to send a
sound alert to your gadget.
Tap on the **Erase iPad**
button to delete the data on
your gadget so that no-one
else can access it

Restricting access

If children have access to your Apple gadgets, you may want to restrict their access in terms of the apps that they can use. On iOS 6 gadgets this is done through the Restrictions settings and on Mountain Lion computers it is done with Parental Controls.

Restrictions on iOS 6
To restrict access to items on iOS 6 gadgets:

1 Access the **General** options in **Settings**

2 Tap on the **Restrictions** link

3 The restrictions are grayed-out, i.e. they have not been enabled for use yet

4 Tap on the **Enable Restrictions** link Enable Restrictions

5 Set a passcode for enabling and disabling restrictions

6 All of the Restrictions options become available. Drag the buttons **On** or **Off** to disable certain apps. If this is done they will no longer be visible on the Home screen. Tap once on the

links under **Allowed Content** to specify restrictions for certain types of content, such as music, movies and apps

Parental Controls on Mountain Lion

To restrict access to items on Mountain Lion computers:

1 Open **System Preferences** and click on the **Users & Groups** button

2 Click on a username and check on the **Enable parental controls** box and click on the **Open Parental Controls...** button

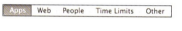

3 Click on these buttons to select restriction options for each category

4 Restrictions can be selected for items such as which apps can be used

5 Time restrictions can also be set to limit the amount of time

that the computer is used during certain periods

Guided Access

The Guided Access option for iOS 6 gadgets allows for certain functionality within an app to be disabled so that individual tasks can be focused on without any other distractions. To use this:

1 Access **Settings > General > Accessibility**. Under the **Learning** heading tap on **Guided Access**

2 Drag this button to **On** to activate the Guided Access functionality

3 Open an app and triple-click on the **Home** button to activate Guided Access

4 Circle an area on the screen to disable it (this can be any functionality within the app). Tap on the **Start** button to begin using the app in Guided Access mode

Locking your gadgets

One security issue with computing gadgets, particularly mobile ones, is preventing unwanted access. If an iOS 6 gadget is left lying around it could be easy for someone to look at what you have stored on it. To prevent this, a passcode can be used to lock the gadget.

1 Access **General** in the **Settings** app

2 Tap on the **Passcode Lock** link

3 Tap on the **Turn Passcode On** link

4 Enter the passcode and re-enter it to confirm it

5 The passcode has to be entered to access the gadget for use every time it has been locked (it will lock itself automatically after a period of inactivity or it can be done with the **Lock** button on the gadget)

Keep it a secret

Backing up gadgets is always good practice and this can be even better if you can encrypt the information, so that it will only be available to someone with a password. For Apple gadgets, this can be done by backing up and encrypting iOS 6 gadgets with a computer running Mountain Lion. To do this:

1 Attach the iOS 6 gadget to the Mountain Lion computer and access it in **iTunes**

2 In the Backup section, check on the **Backup to this computer** button

3 Check on the **Encrypt local backup** button

4 Enter and verify a password and click on the **Set Password** button. The backup will then start

Don't forget

You have to enter the password each time that you want to create a new encrypted backup in this way.